Fractals
Of
Enlightenment

Part IV: Space Core

By Alan Garfoot Jr. Cert. HE

ISBN: 978-1-326-18065-2

Alan Peter Garfoot (2014)

Lulu Press: London

Contents:

Space Core	1
You Did What?	2
Special Dispensation	3
Powers of Protection	4
Meaningful Intent	5
Green Machine	6
Guardian	7
The Doctors Last Breath	8
Sinister Manoeuvre	9
Secret Leader	10
Mean Dream	11
Perfection of the Eather	12
We Can Change This	13
Beneath The Surface	14
Poems of Science	15
Past Tense Suspense	16
Pretty Heroic Deeds	17
A Noble Sadness	18
A Moment of Clarity	19
Crystalline Entity	20
Delta Wave Espionage	21
Subliminal Sight	22
Cosmic Agent	23
Pizik	24
Gene Therapist	25
Attuned To The Cosmic Oneness	26
Keeper of the Art	27
Battle Commander	28
Atlantian Phantasm	29
Ancient Master	30
Torch of the Aeon	31
Tactical Foresight	32
The Cancelled	33
Wild Allegations	34
Perceptual Vibration	35
Selective Programming	36

www.ingramcontent.com/pod-product-compliance
Lightning Source LLC
Chambersburg PA
CBHW072306170526
45158CB00003BA/1213